Artists In The Exhibition

William Allan
Drew Beattie
Robert Bechtle
Marianne Boers
Douglas Bond
Bruce Cohen
Charles Griffin Farr
Randy Hayes
Maxwell Hendler
Don W. Hendricks
Connie Jenkins
David Ligare
Norman Lundin
Richard McLean
Jack Mendenhall
Joseph Raffael
Mary Snowden
Wayne Thiebaud
James Torlakson
Robert Treloar
Mark Wethli
Paul Wonner

WEST COAST REALISM

An Exhibition Organized by Lynn Gamwell

Laguna Beach Museum of Art

This exhibition is funded in part by a grant from the California Arts Council,
the City of Laguna Beach, The Festival of the Arts of Laguna Beach,
the Fluor Foundation and the Institute for Museum Services,
an agency of the United States Government.

Cover:

Jack Mendenhall

Couple on Terrace, 1981, oil on canvas, 44½ x 50,
lent by Howard Rifkin, Woodacre, California

Gamwell, Lynn, 1943–
 West Coast realism.

 "Bibliography of West Coast realist exhibitions":
1. Realism in art—California—Exhibitions.
2. Painting, American—California—Exhibitions.
3. Painting, Modern—20th century—California—Exhibitions.
4. Realism in art—Northwest, Pacific—Exhibitions.
5. Painting, American—Northwest, Pacific—Exhibitions.
6. Painting, Modern—20th century—Northwest, Pacific—
Exhibitions. I. Laguna Beach Museum of Art. II. Title.
ND230.C3G35 1983 759.194′074′019496 83-8257
ISBN 0-940872-03-X

Laguna Beach Museum of Art
307 Cliff Drive, Laguna Beach, California 92651

Itinerary

Laguna Beach Museum of Art
Laguna Beach, California
June 3—July 24, 1983

Museum of Art
Fort Lauderdale, Florida
November 1—December 4, 1983

Center for Visual Arts
Illinois State University
Normal, Illinois
January 15—February 28, 1984

Fresno Art Center
Fresno, California
April 1—May 13, 1984

Louisiana Arts and Science Center
Baton Rouge, Louisiana
June 3—July 15, 1984

Museum of Art
Bowdoin College
Brunswick, Maine
September 7—November 4, 1984

Colorado Springs Fine Arts Center
Colorado Springs, Colorado
November 20—December 18, 1984

Spiva Art Center
Joplin, Missouri
January 6—February 15, 1985

Beaumont Art Museum
Beaumont, Texas
March 8—April 21, 1985

Sierra Nevada Museum of Art
Reno, Nevada
May 5—June 16, 1985

Edison Community College
Fort Meyers, Florida
July 7—August 18, 1985

Lenders to the Exhibition

INDIVIDUALS

Robert Bechtle, San Francisco, California
John Berggruen, San Francisco, California
Bruce Cohen, Santa Monica, California
Mr. and Mrs. Dan Dworsky, Los Angeles, California
Mr. and Mrs. Joseph Houghteling, San Francisco, California
Connie Jenkins, Santa Monica, California
Richard McLean, Oakland, California
Jack Mendenhall, Oakland, California
Byron R. Meyer, San Francisco, California
Howard Rifkin, Woodacre, California
Robert Treloar, San Diego, California
Mark Wethli, Long Beach, California

INSTITUTIONS

Asher/Faure Gallery, Los Angeles, California
John Berggruen Gallery, San Francisco, California
Braunstein Gallery, San Francisco, California
Charles Campbell Gallery, San Francisco, California
Crocker Art Museum, Sacramento, California
Linda Farris Gallery, Seattle, Washington
Fullerton College, Fullerton, California
Gallery Paule Anglim, San Francisco, California
Nancy Hoffman Gallery, New York, New York
Koplin Gallery, Los Angeles, California
Odyssia Gallery, New York, New York
O.K. Harris Works of Art, New York, New York
San Francisco Museum of Modern Art, California
Security Pacific National Bank
Francine Seders Gallery, Seattle, Washington
Tortue Gallery, Santa Monica, California
Turnbull Lutjeans Kogan Gallery (TLK), Costa Mesa, California

Contents

Preface

William G. Otton

Realism and other forms of imagist art have assumed a renewed position of influence in the arena of contemporary art. Representational images are currently part of the content in much of the advanced artwork exhibited in leading galleries and museums such as the 1983 Whitney Biennial. These exhibits indicate that many artists now find a need to use images seen in the visual world to enhance their artistic statements. Thus, "West Coast Realism," a survey of a particular kind of imagist art, has been organized in an environment where representational images are part of a vocabulary used by many segments of the contemporary art community.

During 1982, Dr. Lynn Gamwell organized a southern California realist exhibit entitled, "The Real Thing" for the Laguna Beach Museum of Art. "West Coast Realism" expands the earlier exhibit to include artists living along the Pacific Coast from San Diego to Seattle who are contributing to the realist tradition in American art.

This exhibition reflects the ongoing commitment of the Museum to exhibit and document historically influential visual art being produced in the region. It is a pleasure for the institution to bring these quality artworks by twenty two artists into its galleries.

The Museum is sincerely grateful to Dr. Gamwell for organizing this exhibition and for working with the Art Museum Association to insure a successful travel itinerary for the next two years.

The Board of Trustees must also be given special thanks. These community leaders continue to encourage and support excellence in the visual arts programs for the Laguna Beach Museum of Art.

Financial support for this exhibit came from the California Arts Council, the City of Laguna Beach, the Festival of Arts of Laguna Beach, the Fluor Foundation and the Institute for Museum Services, an agency of the United States Government. Underwriting by these institutions helps the Museum continue to meet its ambitious goals and is sincerely appreciated.

A final note of thanks is appropriate for the creative individuals who have shared their talents with society. The results of their efforts will provide an opportunity for many citizens to learn more about life and have an aesthetic experience when visiting the galleries in which this exhibit will be presented.
April 1983

Acknowledgements

I wish to thank all of the artists who showed me their work, especially those who opened their studios to me. It has been a pleasure to work with the twenty-two artists in this exhibition, and I especially appreciate those who took the time to have a conversation with me about their work. I also benefitted from conversations about realism in the Bay Area and the Pacific Northwest with Bruce Gunther, Curator of Contemporary Art at the Seattle Art Museum, Paul Missal, a Portland artist, George Neubert, Associate Director of the San Francisco Museum of Modern Art, and Marc Tetreault, Director of the Blackfish Gallery in Portland. Sam Davidson, Director of the Davidson Galleries in Seattle, also gave me some excellent advice about his city.

Throughout the preparation of this exhibition I have been aided by the staff of the Laguna Beach Museum of Art. The Director, Dr. William G. Otton, has provided guidance and support for the highest quality exhibition. Suzanne Paulson has added an enriching educational dimension to the exhibition, and Lauri Pelissero has enthusiastically publicized the exhibit. I am especially thankful to the registrar, Heather Hendrickson, for her cheerful assistance with the endless details of catalogue preparation and the handling of the art work. Edythe Mannes also aided the exhibition in the Museum office and Donna Gaikowski did the all-important job of keeping an eye on the finances. Ruth Boyle gave the support of the bookstore to this catalogue. John Hill and Mark Tucker were a terrific installation and security crew, and Michael Williams maintained the building.

I also wish to thank the museum and gallery personnel, and the collectors who assisted me by giving advice, showing me work and in loaning work for the exhibition: Betty Asher of Asher/Faure Gallery in Los Angeles, Jane Oleson and Anne Porter of the Paule Anglim Gallery, John Berggruen of John Berggruen Gallery in San Francisco, Ruth Braunstein of Braunstein Gallery in San Francisco, Charles Campbell of Charles Campbell Gallery in San Francisco, Roger Clisby, Chief Curator and Joanna Ownby, Registrar, of the Crocker Art Museum in Sacramento, Mr. and Mrs. Dan Dworsky of Los Angeles, Linda Farris of Linda Farris Gallery in Seattle, John Parker of Fullerton College in Fullerton, Sique Spence of Nancy Hoffman Gallery in New York, Mr. and Mrs. Joseph Houghteling of San Francisco, Marti Koplin of the Koplin Gallery in Los Angeles, Federico Quadrani of the Odyssia Gallery in New York, Carlo Lamagna of O.K. Harris Works of Art in New York and Robert Harper of O.K. Harris West in Scottsdale, Arizona, Byron R. Meyer of San Francisco, Katherine Church Holland, Research/Collections and Research Director and George Neubert, Associate Director of the San Francisco Museum of Modern Art, Howard Rifkin of Woodacre, California, Virginia S. Jantz and John D. Yue of Security Pacific National Bank, Francine Seders of the Francine Seders Gallery in Seattle, Mallory Freeman of Tortue Gallery in Santa Monica, Betty Turnbull, Phyllis Lutjeans and Victoria Kogan of the Turnbull Lutjeans Kogan Gallery (TLK) in Costa Mesa, California.

The extensive tour of this exhibition was well organized by Jerry Daviee, Program Director of the Art Museum Association in San Francisco.

It is always a pleasure to work with a graphic designer who has the knowledge, experience and impeccable fine taste of Graham Booth. On behalf of everyone involved in WEST COAST REALISM, I thank him for the fabulous job he did in the design and production of this catalogue.

Introduction

My aim in curating WEST COAST REALISM has been to present a critical overview of the best realist artists working in California and the Pacific Northwest. My criteria for "realism" were that the work have a subject from the contemporary world and that it be done in a technique based on direct observation of the subject, aided perhaps by photography. These criteria are based on the historical tradition of realism in fifteenth century Flanders, seventeenth century Holland and nineteenth century France. Realist subjects have always had a wide range—a portrait of a man in a red turban, a woman pouring milk, an anatomy lesson, a luncheon on the grass—events which have in common only the fact that one might actually have seen them in the real world. Techniques have also been quite varied—brushstrokes as tight as Van Eyck and Vermeer or as loose as Hals and Manet—methods linked by their common roots in direct observation of nature.

Although work in this exhibition dates from the mid-1960s to the present, I have only included artists who have remained working on the West Coast, and excluded the many fine realist artists who have relocated elsewhere.

West Coast Realism

Lynn Gamwell

"To be able to translate the customs, ideas, and appearances of my time as I see them—in a word, to create a living art—this has been my aim." Gustave Courbet

WEST COAST REALISM is a critical survey which presents twenty-two realist artists who are presently working in California and the Pacific Northwest. The paintings and drawings in this exhibit, which date from the mid 1960s to the present, have in common a contemporary subject matter and techniques based on direct observation of the world. These artists interpret the world around them and give us a fresh look at the sun culture, the California dream, life in the fast lane and the jacuzzi. Others give us a glimpse into the more private world of an interior or a still life.

Realists living on the West Coast share common themes and methods with artists working throughout the country and, in one way or another, the artists in this exhibition are all part of the national revival of the realist style in recent years. On a regional level, certain realists have worked under the influence of strong local figurative traditions on the West Coast, while others reflect the variety of weather, light, geography and lifestyles of the three major art centers: the San Francisco Bay Area, the Pacific Northwest and Southern California.

The San Francisco Bay Area

In the decades after World War II, Elmer Bischoff, Richard Diebenkorn and David Park painted figures and landscapes in a loose gestural style which became known as the Bay Area Figurative style. Although these artists and others who later became associated with them, such as Nathan Oliveira, were expressionists who were heavily influenced by Abstract Expressionism, the Bay Area Figurative style has also affected the look of realism in the Bay Area. The main effect is that the painting techniques of certain artists are much looser than are generally associated with realism. The strong design format of Diebenkorn's work has also been influential.

Of the artists in WEST COAST REALISM, Paul Wonner has the most direct link with the Bay Area Figurative tradition. After spending several years in New York in the late 1940s during the height of Abstract Expressionism, Wonner settled in the Bay Area where he developed a gestural figurative style. In 1957 he was included with Bischoff, Diebenkorn and Park in the definitive exhibition *California Bay Area Figurative Painters* which was organized by the Oakland Museum.

During the 1960s, Wonner increasingly tightened his brushwork in paintings of still lifes, which he designed on an abstract, geometric scaffolding which recalls Diebenkorn's formats of the same decade. Wonner acknowledges the historical roots of his still life by titles such as *Dutch Still Life with Primroses* and by including references to seventeenth century Dutch realism, such as the postcard in this painting. The bottle and jar update the subject to the twentieth century and the sunshine streaming in locates it in California. Although living permanently in San Francisco since 1976, Wonner earlier taught at many institutions throughout California, and has been very influential on younger artists.

Throughout his thirty year career in Northern California, Wayne Thiebaud has become known for his paintings and drawings of everyday objects, done in a loose, gestural style. *Penny Machines* is typical of Thiebaud's lusciously painted objects of pleasure. Here is a slot machine presented as a joyful grown-up toy.

Joseph Raffael began his career in New York and settled permanently in the Bay Area in 1969 at the age of thirty-six. The dramatic style shift which occurred in his work in the next decade was documented in *Joseph Raffael: The California Years* which was organized by the San Francisco Museum of Modern Art in 1978. In paintings in that exhibition, as in *Orange Fish* of 1979, Raffael's specifically Bay Area look is clear. The paint application is transparent and loose, and the subject is a pleasant view of light, water and nature.

Although Raffael works from a gridded blowup of a photograph, the final painting has a gestural quality which is quite unphotographic. Raffael's "loosest" paintings remind one of how loose and abstract the sketches of the Old Masters such as Rembrandt were, and how broad the technical limitations of "realism" are.

During the sixties Robert Bechtle and Richard McLean established studios in the East Bay and developed a realist style which was rooted more specifically in the photograph. The term "photorealism" which is commonly used to describe their paintings, means that their work looks like paintings of a photograph of some scene. (Most realists use photos as an aid at some time during the production of a painting, but for most the finished painting does not have a specifically "photographic" appearance, as it does for Bechtle and McLean.) Both artists attended the California College of Arts and Crafts during the fifties when Diebenkorn was on the faculty. Both Bechtle and McLean have acknowledged Diebenkorn's influence on their painting, although both tightened their brushstrokes as they moved closer to the photo as a source for their work.

Bechtle works from snapshot photos and his paintings show familiar Berkeley streets and people. There is nothing casual, however, about the calculated composition and precise value relations of his paintings such as *Alameda Gran Torino*. Bechtle also edits out details to create strong, simplified images. When Bechtle includes figures, such as in *French Doors* II, he typically isolates the figures, creating a mood which recalls the work of Edward Hopper.

Richard McLean began working from photos he found in horse breeders' magazines in the early sixties. Within two years he began going to horse shows to take the photographs himself, and he has continued to take all of the source photographs for his paintings and watercolors. According to the artist, he has no emotional attachment to the horse breeders' world whatsoever, and believes that this indifference towards content allows him to focus more on formal issues, such as the strong frontal composition and light and dark pattern in *Boiler Maker*. McLean's view that the subject is of minor importance might seem rather surprising when you are standing in front of *Boiler Maker* staring into the eyes of that very impressive horse. However, this is actually a very common attitude among artists who work directly from photographs, especially first generation photorealists, like McLean, who were trained in an abstract tradition.

In the early 1970s, Bechtle and McLean were joined in the East Bay by a third photorealist, Jack

Mendenhall, who was also trained at the California College of Arts and Crafts, and established his studio in Oakland. Mendenhall paints the environment of beautiful wealthy people, working from photographs of elegant lifestyles which he clips from fashionable magazines. *Couple on Veranda*, which was painted from a liquor advertisement in *Architectural Digest*, presents a gracious man and woman painted in a refined and sophisticated manner. The final impact of Mendenhall's art is a fantasy lifestyle which forms part of the California dream.

During the development of the Bay Area Figurative style in the 1940s, another strong painter settled in San Francisco with a figurative style unrelated to Abstract Expressionism. Charles Griffin Farr was born in Alabama and trained in New York at the Art Students' League and the studio of George Luks. As his style developed in the late thirties, Farr always identified with the tradition of American Realists and, as an artist, has always felt closest to Cézanne. San Francisco has been his home since 1948 and he has taught for many years both privately and at the San Francisco Art Institute. *The Rocky Beach*, which Farr painted from an actual place just south of Half Moon Bay, we see the artist's style which has remained unwavering for his fifty-year career. The painting has simplified, clear-cut forms, precise composition and a cool, peaceful mood.

William Allan was trained in San Francisco in the late 1950s and has continued to live and work in Northern California. In the early 1970s, Allan underwent a style change and began the fish imagery for which he is known today. Allan locked up his studio for two years and spent long periods of time in the wilderness of California and his native Washington state. There he sought a natural existence, away from art world artificiality, and began painting simple, direct watercolors of fish. *Albacore* is from the first series which Allan did outside the United States in Baja California (Mexico), where he spent several years fishing and photographing marlins and tunas. In this painting of an albacore, which is in the tuna family, Allan captures the iridescence of that fish.

David Ligare bases his art in the Classical tradition of Ancient Greece and French Neoclassicism, but, like any good revivalist, he fuses that tradition with his own time and place—Northern California in the late twentieth century. In *Woman in a Greek Chair (Penelope)*, Ligare painted a woman in Santa Barbara in

the role of "Penelope" from the *Illiad*, wearing a Greek chiton and in a pose which recalls Jacques-Louis David's *Madame Recamier*. Ligare updates this image by making the lady less idealized than her Classical ancestors, with thick-skinned feet. She sits in a mass-produced version of the Ancient Greek chair—with a rattan seat and metal bolts. The lovely seascape background could be either the Pacific or the Aegean Sea, and is perhaps our best clue to a California artist's identification with this past.

Of the younger Bay Area artists in WEST COAST REALISM, James Torlakson and Drew Beattie are the closest stylistically to the East Bay photorealists and the stark realism of Edward Hopper. Torlakson grew up in San Francisco and studied with Bechtle at San Francisco State University. His subjects include roads, cars, trucks and trains, all rendered with meticulous, somewhat chilly, watercolor technique from photographs which he himself takes. 2266 depicts an old train yard in Brisbane, just north of San Francisco. Beattie was trained in Boston, where he began painting pictures of houses, and he came to Berkeley in 1979 to assume a teaching position at the University of California. There he was drawn to the old Berkeley stucco houses, such as the one in *Holiday*. Beattie presents the house as a being, giving the depicted image a presence much like a person. The artist also heightens the drama by including small, somewhat anonymous inhabitants. In the end Beattie's paintings focus on the psychological relationship between a house and its inhabitants.

Mary Snowden and Mary Ann Boers are both watercolorists, trained in the Bay Area, who paint traditional still lifes and landscapes. Snowden sometimes paints whimsical children's imagery, or does more straightforward subjects such as *Kitchen Flowers*. *Quaker Oats* by Mary Ann Boers, is similarly a loose, watercolor interpretation of common household objects.

The Pacific Northwest

The concept of a "Northwest School" was much discussed in the 1940s and '50s in reference to artists in Seattle and Portland (Mark Tobey, Morris Graves, Kenneth Callahan, Charles Heaney) who shared common features of a dense, impasto surface, grayed color, and somewhat dreary (in Tobey's case "mysti-

cal'') subject matter. Tobey, the strongest artist from the area, in fact lived in the Northwest less than five years and had little influence on the next generation of artists in Seattle. The idea of a ''regional look'' or a ''school'' is today quite unpopular, especially in Seattle where a large, sophisticated art community has gained national visibility.

Norman Lundin is known for his pastel and chalk drawings of interiors. Lundin does not work from a specific scene, but rather constructs his interiors mentally and aims to capture a particular light. Indeed his work, such as *Studio: Interior*, has a very cerebral quality and appears carefully conceived. Despite the Seattle art community's resistance to ''regionalism'' (including Lundin, who points out that the *Studio* series was begun in sunny San Antonio) one wonders at the effect of the months of sunless, rainy weather when confronted with an artist like Lundin who works exclusively in grayed color. It's also interesting to note that Lundin is of Norwegian descent and has made several trips to the land of Munch's dark and dreary vision.

Randy Hayes is a younger artist who was trained in Boston and has lived in Seattle only since the mid-1970s. His colors are brilliant, his application of pastel on paper is loose and aggressive, and he presents tough views of the boxing world. Working from photos which he takes at ringside, Hayes' life-size images retain a snapshot composition and the immediacy of the spectator, reminiscent of pastels by Degas and Toulouse-Lautrec. *Flash* juxtaposes the suffering of the bleeding fighter against the vanity of the girl who grins for the camera.

Southern California

The ''mainstream'' art of Southern California since the Second World War has been predominantly non-objective. The strongest painters of the 1940s and '50s, who include Lorser Feitelson, Karl Benjamin, Florence Arnold and John Mclaughlin, painted geometric abstractions. Sam Francis settled in Santa Monica in the early sixties, staining and spattering canvases under the influence of Abstract Expressionism. When Richard Diebenkorn moved to Los Angeles in the late '60s he had adopted a totally abstract style and did his Ocean Park series of large geometric shapes which had only the most minimal land-

scape reference. The "Cool School" which dominated Los Angeles in the '60s, had a pristine geometric finish and was non-objective with a vengeance.

Realist painters in Southern California are a very diverse lot. Natives lack strong "older generation" painters as role models, and the notorious urban sprawl and mobile population makes any sense of community among artists unlikely. Many come to the area for some combination of jobs, weather and the art scene, bringing with them a variety of backgrounds.

Douglas Bond was born in Georgia and settled in Southern California in the late 1950s. By the mid-'60s he was working in the photorealist style for which he is known, painting from nostalgic period photos taken from magazine advertisements. The painting of the barbeque (*Untitled*, 1981) presents the immaculately clean world of advertising, which is the only place where a barbeque would be polished and the cook's gloves and apron spotless.

Don Hendricks' early work had a very photorealist appearance and was drawn in pencil on paper from snapshots of '50s cars, girls in hot pants, and other memorabilia of the American male. His more recent work in watercolor, although also done largely from photographs, has moved away from that fetishistic preoccupation with nailing down every detail (to which all photorealists are prone), to a more fluid, moodier, more psychologically complex presentation of figures and places. *Saturday Morning* depicts Hendricks' adolescent son in a shadowy doorway and beautifully evokes the dark uncertainties of that time of life. In outdoor subjects, Hendricks illuminates tropical and desert vegetation and old Spanish style buildings with the brilliant Southern California sun.

Connie Jenkins presents a peaceful, sunlit, inviting image of the sea. She lives a few blocks from the beach in Santa Monica and shares the local preoccupation with surf and sand. Using a combination of airbrush and direct painting with a brush, she creates a powerful image set in a modernist overall format. As a politically conscious parent, she focuses her concern on the suffering of children around the world and thinks of many of her paintings as quiet memorials to them. *We Shall Never Know Their Names* is in remembrance of the massacre of peasants in El Salvador in the summer of 1981.

Maxwell Hendler and Mark Wethli are the most traditional realists working in Southern California in the sense of preferring to work from life, if at all practical, and sharing most directly the concerns of the Old Masters of realism. Hendler has been centered in the Los Angeles area since the mid-'50s and, although somewhat of a recluse and not as well known as other realists of his decade, he has been included in major exhibitions throughout the years. His watercolor of the WD-40 can and the brick (*Untitled*, 1980) manifests Hendler's fantastic ability to record objects and give them an icon-like presence. In the city of freeways and fast food, it is rare to know an artist who is willing to spend the better part of a year recording every minute detail of humble objects in one small watercolor. Hendler's meditative attitude and the exquisitely rendered objects he produces, reminds one of the Flemish masters and the tiny still lifes which they included in their altarpieces.

Mark Wethli was trained in Miami, has worked in New York, and came to Southern California only recently to teach at the California State University at Long Beach. His work relates not at all to a Southern California milieu, nor to any other place he has lived for that matter, but has a timeless, universal quality that has more to do with Van Eyck and Vermeer than with contemporary variations on realism. *Landing* is like a twentieth-century version of those masters. It retains their formal concerns—clear design, single light source, colored shadows and immaculate oil glazing—but like our times *Landing* is demythologized and depersonalized. Wethli added the vase of flowers at the completion of the painting—a subtle acknowledgement of a human presence.

Robert Treloar and Bruce Cohen are both younger artists who are native to Southern California. Treloar went to San Diego State University, where he met Artist-in-Residence Jack Beal. Beal and Treloar subsequently painted together for two years on four large murals depicting the history of labor, which were commissioned for the Department of Labor building in Washington, D.C. Robert Treloar's work has a rich painterly appearance, whether done in oil or pastels. He depicts his friends and neighbors in San Diego, where he was raised and presently lives, and, as in *Woman in Jacuzzi* shows us their pleasant, sundrenched surroundings.

Bruce Cohen paints interiors which exist on the borderline between realism and abstraction. Working under the influence of Paul Wonner, whom Cohen met while Wonner was a guest artist at UC Santa Barbara, Cohen increases the tension between realism and abstraction which one finds in Wonner's work. Cohen makes the objects more "real" by painting the shoes and pillow in *Untitled* in meticulous detail from life, and makes the space more abstract by avoiding diagonal perspective altogether. Cohen's final image is cool and distilled.

The paintings in WEST COAST REALISM make it evident that realism is a strong and viable style in California and the Pacific Northwest. Accomplished figures from the older generation continue to paint their contemporary surroundings and younger artists are drawn to that pursuit. The simple act of painting one's surroundings is something artists throughout history have always done. We give it different names at different times—"Ash Can School," "Pop Art," "Photorealism"—but the basic desire to make a lasting image of one's world remains the same. Today on the West Coast, artists of the highest quality are making beautiful images of our world for the future.

Selected Works in Exhibition

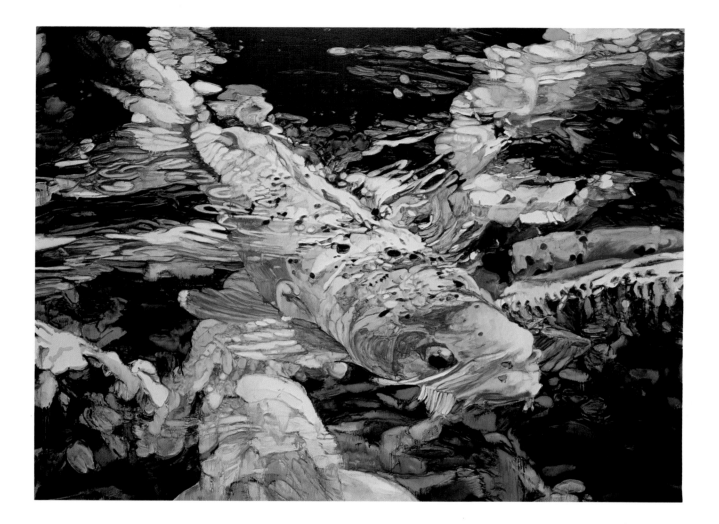

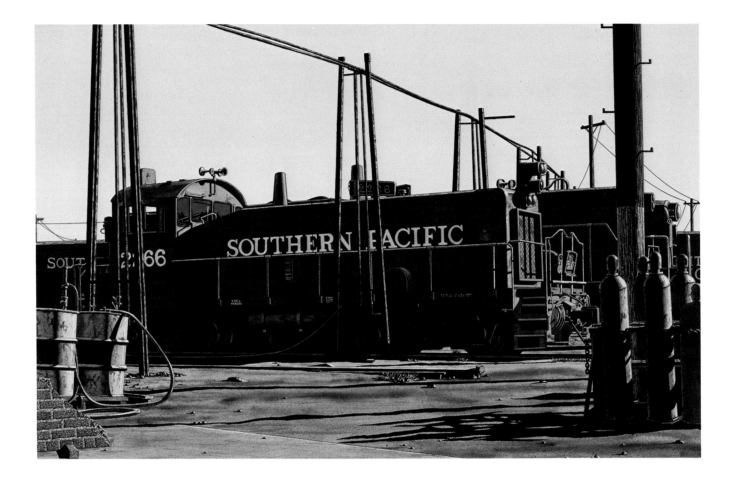

James Torlakson

2266, 1978, watercolor, 19½ x 25, lent by John Berggruen Gallery,
San Francisco, California

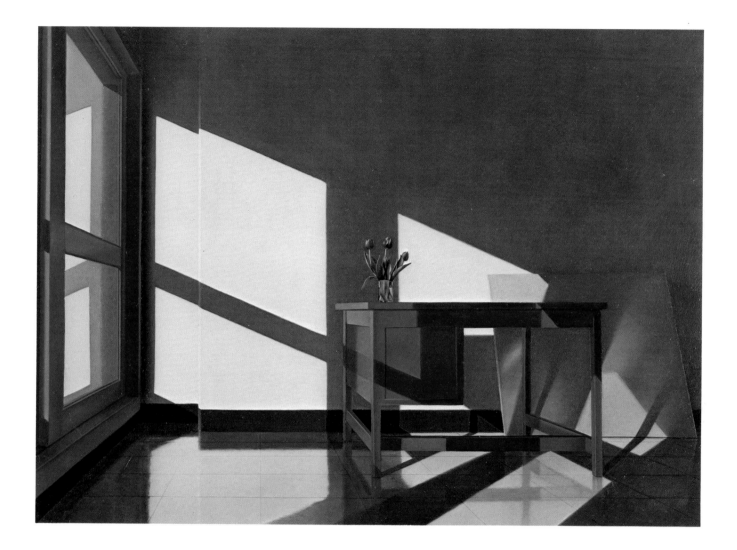

Mark Wethli

Landing, 1982, acrylic and oil on paper, 9 x 12, lent anonymously
(Photograph by Rick de Fina)

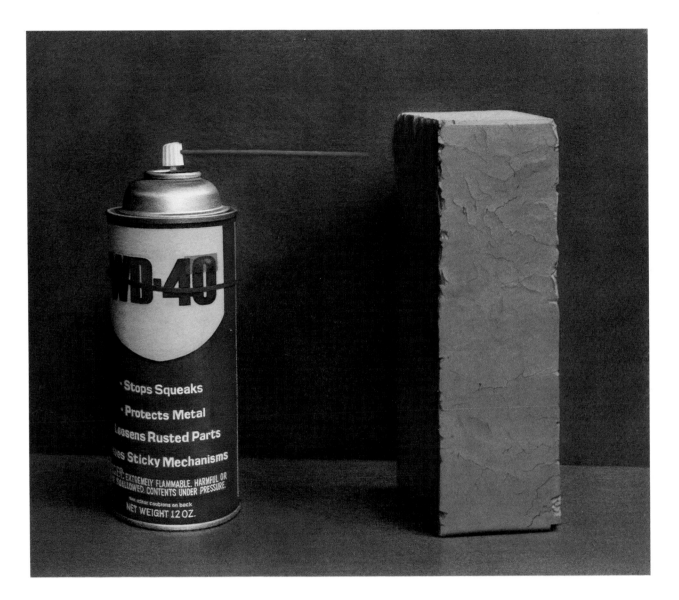

Maxwell Hendler

Untitled, 1980, watercolor, 8½ x 9⅝, lent by Asher/Faure Gallery,
Los Angeles, California
(Photograph by Susan Einstein)

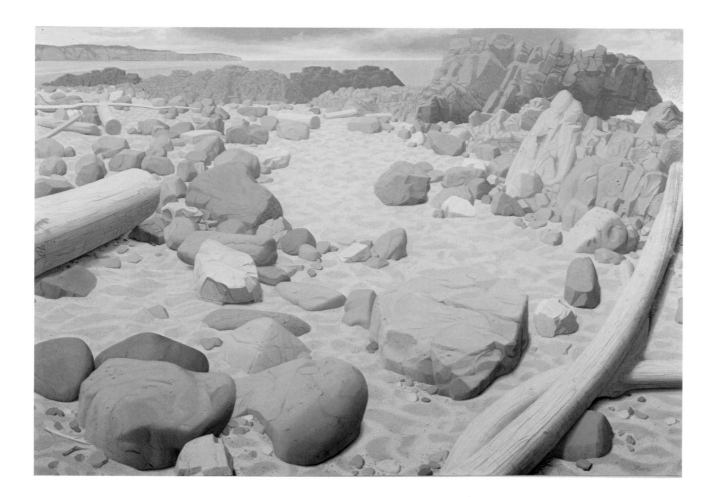

Charles Griffin Farr

The Rocky Beach, 1975, oil on canvas, 66 x 45, lent by Mr. and Mrs. Joseph Houghteling
San Francisco, California

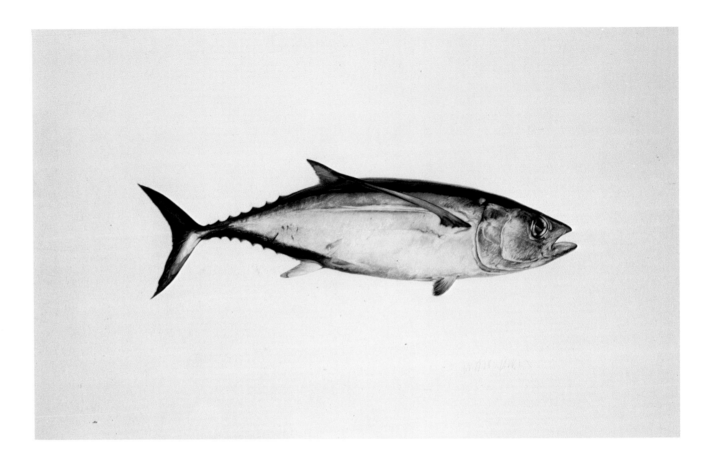

William Allan

Albacore, 1980, watercolor, 24½ x 37¾, lent by Odyssia Gallery,
New York, New York

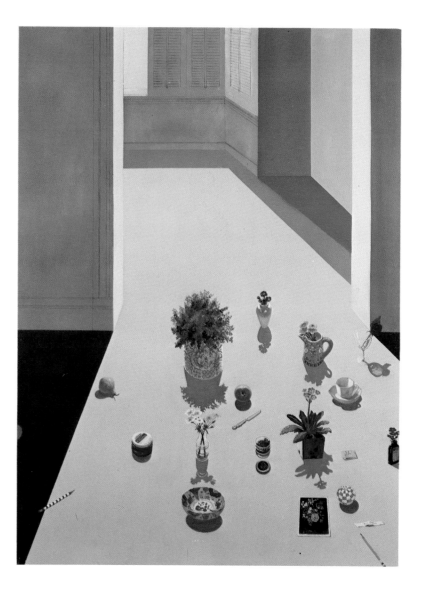

Paul Wonner

Dutch Still Life with Primroses, 1977-1978, acrylic on canvas, 70 x 50, lent by the Security Pacific National Bank,
San Francisco, California

31

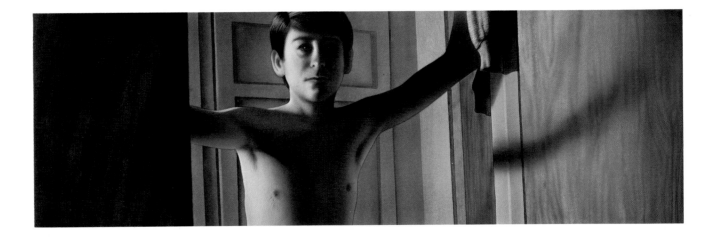

Don W. Hendricks

Saturday Morning, 1982, watercolor, 13 x 36, lent by Turnbull Lutjeans Kogan Gallery (TLK),
Costa Mesa, California (Photograph by Rick de Fina)

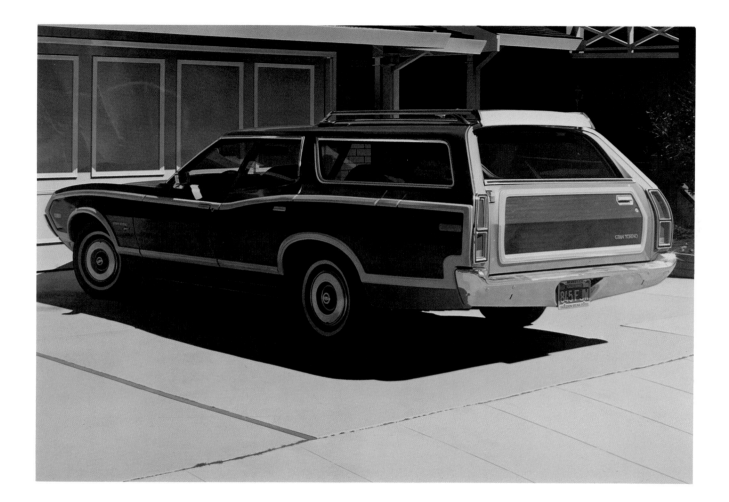

Robert Bechtle

Alamenda Gran Torino, 1974, oil on canvas, 48 x 69, lent by the San Francisco Museum of Modern Art, T.B. Walker Foundation Fund,
Purchase in honor of John Humphrey

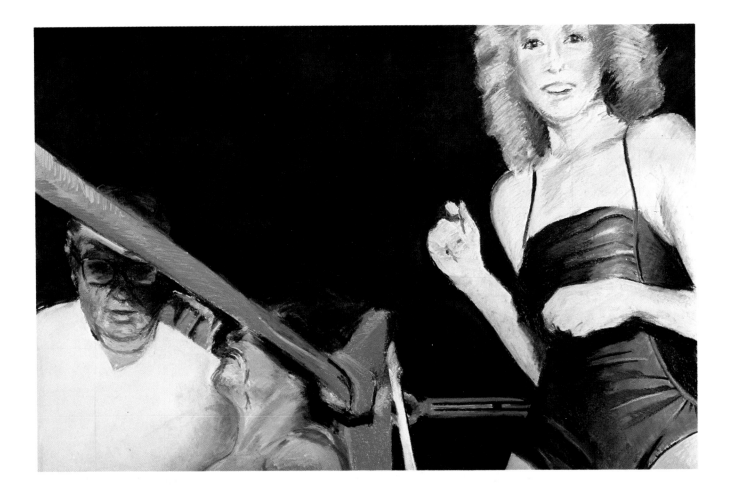

Randy Hayes

Flash, 1982, pastel on paper, 40 x 60, lent by Linda Farris Gallery,
Seattle, Washington

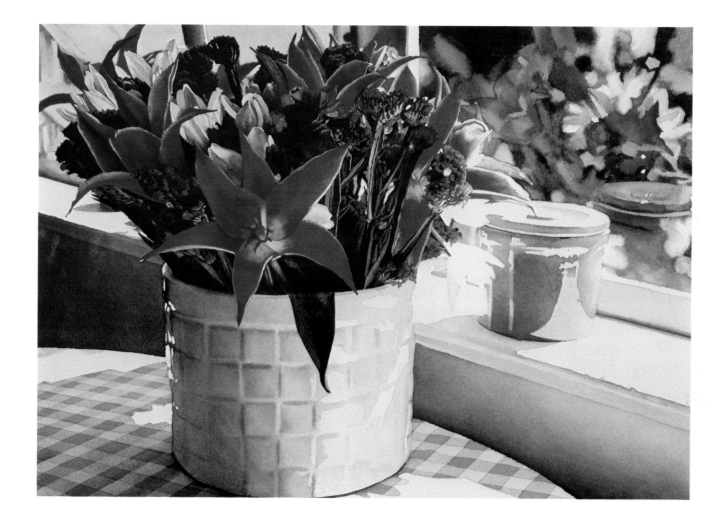

Mary Snowden

Kitchen Flowers, 1982, watercolor, 22½ x 30, lent by Braunstein Gallery,
San Francisco, California

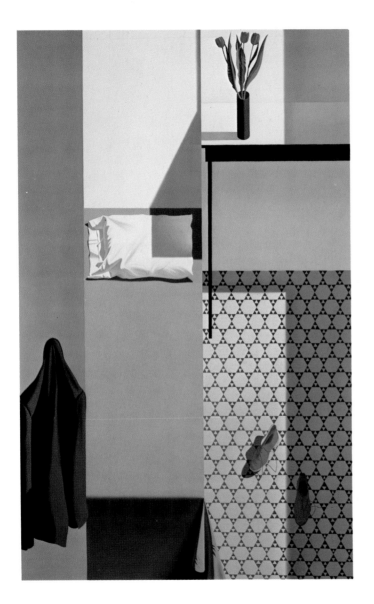

Bruce Cohen

Untitled, 1982, oil on canvas, 66 x 40, lent by Asher/Faure Gallery,
Los Angeles, California (Photograph by Susan Einstein)

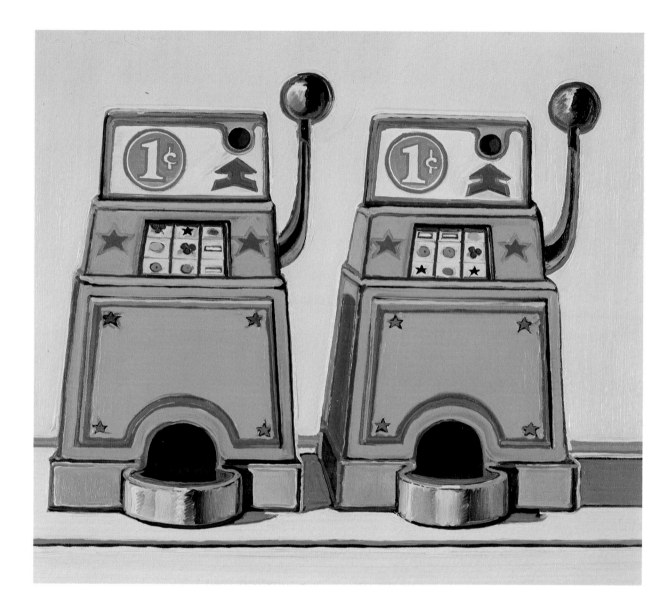

Wayne Thiebaud

Penny Machines, 1964, oil on canvas, 19 x 21, lent by Fullerton College,
Fullerton, California

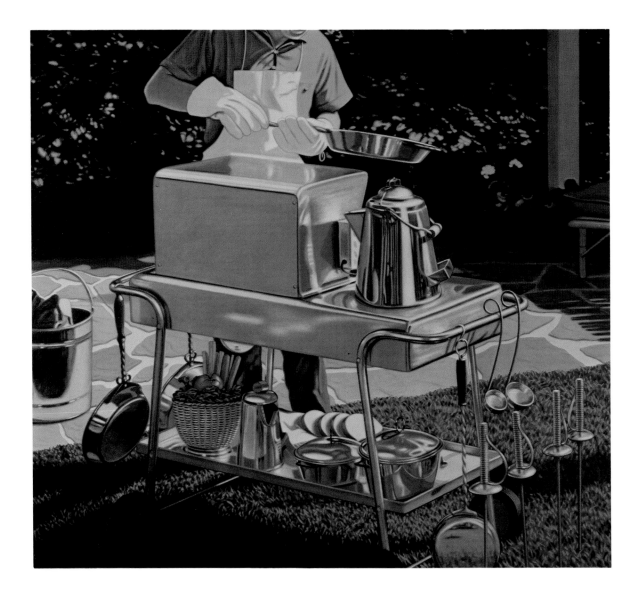

Douglas Bond

Untitled, 1981, acrylic on canvas, 49 x 52½, lent by O.K. Harris Works of Art,
New York, New York

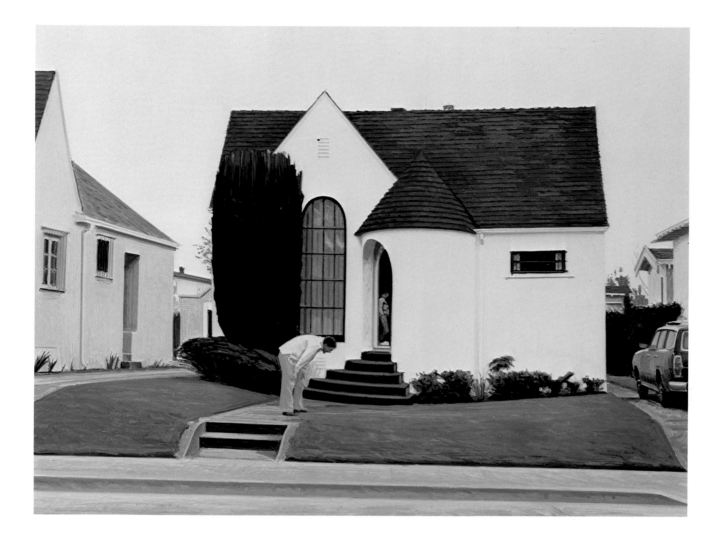

Drew Beattie

Holiday, 1982, oil on masonite, 16½ x 22, lent by Gallery Paule Anglim,
San Francisco, California

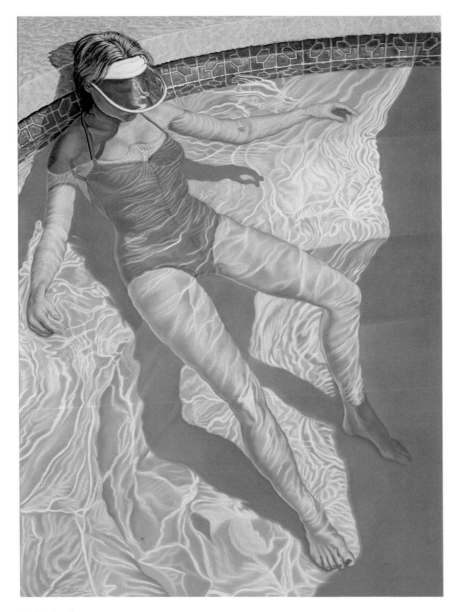

Robert Treloar

Joyce, 1980, pastel on paper, 58 x 42, lent by the artist

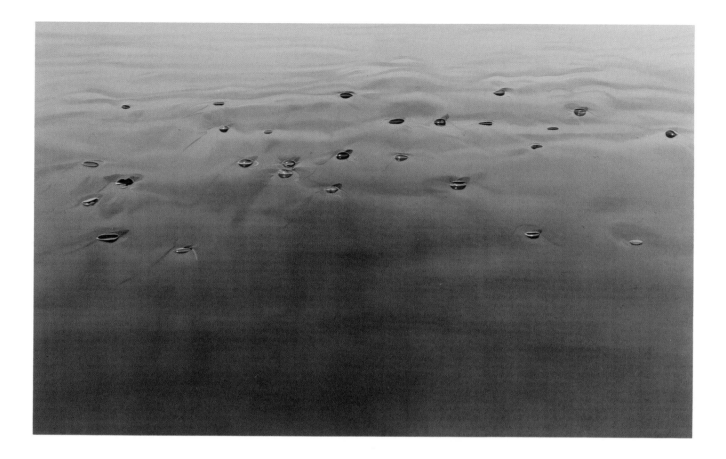

Connie Jenkins

We Shall Never Know Their Names, 1982, oil on canvas, 65 x 105, lent by the Koplin Gallery, Los Angeles, California (Photograph by Tom Vinetz)

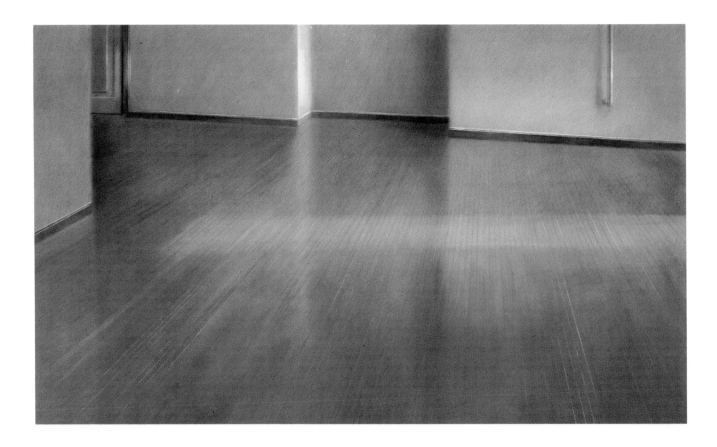

Norman Lundin

Studio: Light on Floor, 1983, mixed media on paper, 34 x 50, lent by Francine Seders Gallery, Seattle, Washington

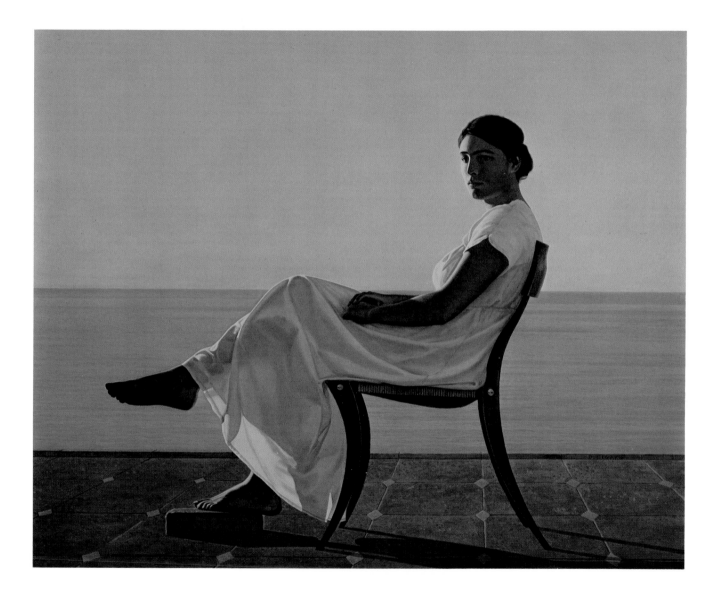

David Ligare

Woman in a Greek Chair (Penelope), 1980, oil on canvas, 60 x 72, lent by the Koplin Gallery,
Los Angeles, California

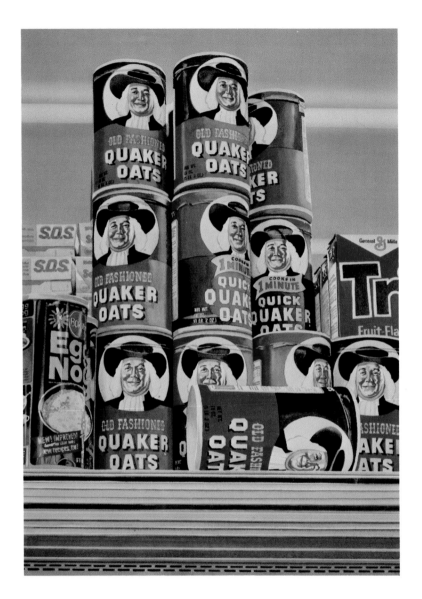

Marianne Boers

Quaker Oats, 1976, watercolor, 30⅛ x 22, lent by John Berggruen,
San Francisco, California

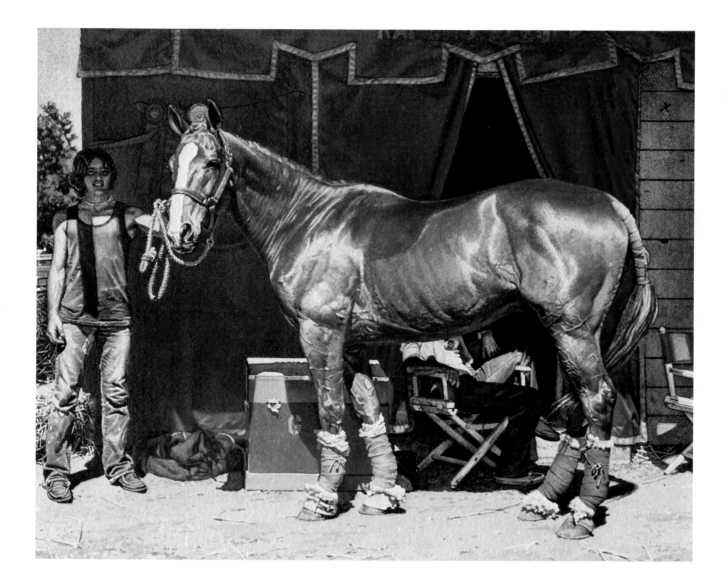

Richard McLean

Boiler Maker, 1976, watercolor, 10½ x 12¾, collection Byron R. Meyer.
San Francisco (Photograph by M. Lee Fatherree)

Exhibition and Biography List

Dimensions are given in inches; height precedes width precedes depth.
All information has been supplied by the lenders.

* indicates that the work is illustrated in the catalogue.
(x) indicates that the work is exhibited only at the Laguna Beach Museum of Art.
(y) indicates that the work is exhibited only at the Laguna Beach Museum of Art, the Museum of Art in Fort Lauderdale, the Center for Visual Arts at the Illinois State University at Normal, the Fresno Art Center and the Louisiana Arts and Science Center in Baton Rouge.
(z) indicates that the work is exhibited only at the Museum of Art at Bowdoin College, the Colorado Springs Fine Arts Center, the Spiva Art Center, the Beaumont Art Museum, the Sierra Nevada Museum of Art and Edison Community College in Fort Meyers, Florida.

William Allan
Born in Everett, Washington in 1936
Educated at the San Francisco Art Institute,
BFA in 1958
Lives in Sacramento, California
Represented by Odyssia Gallery, New York, New York,
and Hansen Fuller Goldeen, San Francisco, California

Brown Trout Head—Madison River, 1972.
watercolor, 30½ x 22½
Lent by Odyssia Gallery, New York, New York

* *Albacore*, 1980
watercolor, 24½ x 37¾
Lent by Odyssia Gallery, New York, New York

Drew Beattie

Born in Atlanta, Georgia in 1952

Educated at the Skowhegan School of Painting and Sculpture in Maine and the School of the Museum of
Fine Arts in Boston, MFA

Lives in Berkeley, California

Represented by the Gallery Paule Anglim, San Francisco, California

* *Holiday,* 1982
oil on masonite, 16½ x 22
Lent by Gallery Paule Anglim, San Francisco, California

Ray, 1982
oil on masonite, 16½ x 22
Lent by Gallery Paule Anglim, San Francisco, California

Robert Bechtle

Born in San Francisco, California in 1932

Educated at the University of California at Berkeley and the
California College of Arts and Crafts,
BA in 1954 and MFA in 1958

Lives in San Francisco, California

Represented by O.K. Harris Works of Art, New York, New York

French Doors II, 1966
oil on canvas, 72 x 62
Lent by the Crocker Art Museum, Sacramento, California

* (y) *Alameda Gran Torino*, 1974
oil on canvas, 48 x 69
Lent by the San Francisco Museum of Modern Art, T.B. Walker Foundation Fund Purchase in honor of
John Humphrey

(z) *Watsonville Chairs*, 1975
watercolor, 10 x 15
Lent by the artist

Marianne Boers
Born in Modesto, California in 1945
Educated at Immaculate Heart College, Los Angeles,
and San Francisco State College, BA in 1971 and MFA in 1975
Lives in San Francisco, California
Represented by John Berggruen Gallery, San Francisco, California

Untitled, 1972
watercolor, 22 x 30
Lent by John Berggruen, San Francisco, California

* *Quaker Oats*, 1976
watercolor, 30⅛ x 22
Lent by John Berggruen, San Francisco, California

Douglas Bond
Born in Atlanta, Georgia in 1937
Educated at California State College at Los Angeles,
BA in 1965 and MFA in 1966

Lives in Pasadena, California

Represented by O.K. Harris Works of Art, New York, New York

Aryan Notes, 1976
acrylic on canvas, 54 x 47
Lent by Tortue Gallery, Santa Monica, California

* *Untitled*, 1981
acrylic on canvas, 49 x 52½
Lent by O.K. Harris Works of Art, New York, New York

Bruce Cohen
Born in Santa Monica, California in 1953
Educated at the University of California at Los Angeles,
Berkeley and Santa Barbara, BA in 1975
Lives in Santa Monica, California
Represented by Asher/Faure Gallery, Los Angeles, California

(x) *Untitled*, 1982-83
oil on canvas, 66 x 40
Lent by the artist

* *Untitled*, 1982
oil on canvas, 66 x 40
Lent by Asher/Faure Gallery, Los Angeles, California

Untitled, 1982
oil on canvas, 66¼ x 40
Lent by Asher/Faure Gallery, Los Angeles, California

Charles Griffin Farr

Born in Birmingham, Alabama in 1908
Educated at the Art Students' League in New York,
under Jean Despujols in Paris, and the California School
of Fine Arts in San Francisco
Lives in San Francisco, California
Represented by Charles Campbell Gallery,
San Francisco, California

* *The Rocky Beach*, 1975
oil on canvas, 66 x 45
Lent by Mr. and Mrs. Joseph Houghteling,
San Francisco, California

Iris and Calla Lilies, 1982
oil on canvas, 26 x 30
Lent by Charles Campbell Gallery, San Francisco, California

Randy Hayes

Born in Jackson, Mississippi in 1944
Educated at Southwestern at Memphis in Tennessee,
the Memphis Academy of Art, BFA in 1968, and the
University of Oregon in Eugene
Lives in Seattle, Washington
Represented by Linda Farris Gallery, Seattle, Washington

* *Flash*, 1982
pastel on paper, 40 x 60
Lent by Linda Farris Gallery, Seattle, Washington

Seconds, 1982
pastel on paper, 39¼ x 53¼
Lent by Linda Farris Gallery, Seattle, Washington

Maxwell Hendler
Born in St. Louis, Missouri in 1938
Educated at the University of California at Los Angeles,
BA in 1960 and MA in 1962
Lives in Los Angeles, California
Represented by Asher/Faure Gallery, Los Angeles,
California and Robert Miller Gallery, New York, New York

* *Untitled*, 1980
watercolor, 8½ x 9⅝
Lent by Asher/Faure Gallery, Los Angeles, California

Untitled, 1980
watercolor, 8½ x 11⅛
Lent by Asher/Faure Gallery, Los Angeles, California

Don W. Hendricks
Born in San Diego, California in 1947
Educated at the California State University in Fullerton,
BA in 1971 and MFA in 1972
Lives in Fullerton, California
Represented by Turnbull Lutjeans Kogan Gallery (TLK), Costa Mesa, California

Pirates, 1982
watercolor, 12 x 36
Lent by Turnbull Lutjeans Kogan Gallery (TLK), Costa Mesa, California

* *Saturday Morning*, 1982
watercolor, 13 x 36
Lent by Turnbull Lutjeans Kogan Gallery (TLK), Costa Mesa, California

Connie Jenkins
Born in Lubbock, Texas in 1945
Educated at the University of Colorado in Boulder,
BA in 1967 and MFA in 1972
Lives in Santa Monica, California
Represented by the Koplin Gallery, Los Angeles, California

(x) *Disappearing Balls*, 1978-1979
oil on canvas, 72 x 117
Lent by Mr. and Mrs. Dan Dworsky, Los Angeles, California

In Memory, Atlanta, 1981
prismacolor pencil on paper, 20 x 20
Lent by the artist

* *We Shall Never Know Their Names*, 1982
oil on canvas, 65 x 105
Lent by the Koplin Gallery, Los Angeles, California

David Ligare
Born in Oak Park, Illinois in 1945

Educated at Art Center College of Design in Los Angeles, California

Lives in Salinas, California

Represented by Koplin Gallery, Los Angeles, California

* *Woman in a Greek Chair* (*Penelope*), 1980
oil on canvas, 60 x 72
Lent by the Koplin Gallery, Los Angeles, California

Three Women
pencil on paper, 22 x 30
Lent by the Koplin Gallery, Los Angeles, California

Norman Lundin

Born in Los Angeles, California in 1938

Educated at the University of Chicago, the School
of The Art Institute of Chicago, BA in 1961,
the University of Oslo in Norway,
and the University of Cincinnati in Ohio, MFA in 1963

Lives in Seattle, Washington

Represented by Francine Seders Gallery, Seattle, Washington

* *Studio: Light on Floor*, 1983
mixed media on paper, 34 x 50
Lent by Francine Seders Gallery, Seattle, Washington

Studio Series #14, 1983
mixed media on paper, 34 x 50
Lent by Francine Seders Gallery, Seattle, Washington

Richard McLean

Born in Hoquiam, Washington in 1934
Educated at the California College of Arts and Crafts, BFA in 1958, and Mills College in Oakland,
California, MFA in 1962
Lives in Oakland, California
Represented by O.K. Harris Works of Art, New York, New York

* *Boiler Maker,* 1976
watercolor, 10½ x 12¾
Collection Byron R. Meyer, San Francisco

(x) *Satin Doll,* 1978
oil on canvas, 54 x 60
Lent by the artist

Jack Mendenhall

Born in Ventura, California in 1937
Educated at the California College of Arts and Crafts,
BFA in 1968, and MFA in 1970
Lives in Oakland, California
Represented by O.K Harris Works of Art, New York, New York

Bathroom, 1976-1978
oil on canvas, 48 x 36
Lent by the artist, courtesy of O.K. Harris Works of Art,
New York, New York

* *Couple on Terrace*, 1981
oil on canvas, 44½ x 50
Lent by Howard Rifkin, Woodacre, California

Joseph Raffael
Born in Brooklyn, New York in 1933
Educated at the Cooper Union School of Art in New York,
and Yale University, New Haven, Connecticut, BFA in 1956
Lives in San Geronimo, California
Represented by Nancy Hoffman Gallery, New York, New York,
and John Berggruen Gallery, San Francisco, California

* *Orange Fish*, 1979
oil on canvas, 66 x 90
Lent by Nancy Hoffman Gallery, New York, New York

A Secret Path, 1980
watercolor and pastel on paper, 53½ x 43¾
Lent by Nancy Hoffman Gallery, New York, New York

Mary Snowden
Born in Pennsylvania in 1940
Educated at Brown University in Rhode Island, BA in 1962
and the University of California at Berkeley, MFA in 1964
Lives in San Francisco, California
Represented by Braunstein Gallery, San Francisco, California

Beyond Measure, 1982
watercolor, 25¾ x 28¾
Lent by Braunstein Gallery, San Francisco, California

* *Kitchen Flowers*, 1982
watercolor, 22½ x 30
Lent by Braunstein Gallery, San Francisco, California

Wayne Thiebaud
Born in Mesa, Arizona in 1920
Educated at the California State University in Sacramento,
BA in 1950 and MA in 1953
Lives in Sacramento and San Francisco, California
Represented by Allan Stone Gallery, New York, New York,
and John Berggruen Gallery, San Francisco, California

* *Penny Machines*, 1964
oil on canvas, 19 x 21
Lent by Fullerton College, Fullerton, California

James Torlakson
Born in San Francisco, California in 1951
Educated at the California College of Arts and Crafts,
BFA in 1973, and San Francisco State University, MA in 1974
Lives in Pacifica, California
Represented by John Berggruen Gallery,
San Francisco, California

San Gregorio II, 1975
watercolor, 13½ x 20
Lent by John Berggruen Gallery, San Francisco, California

* 2266, 1978
watercolor, 19½ x 25
Lent by John Berggruen Gallery, San Francisco, California

Robert Treloar
Born in Newport, Rhode Island in 1948
Educated at San Diego State University, BA and MFA
Lives in San Diego, California

* *Joyce*, 1980
pastel on paper, 58 x 42
Lent by the artist

August, 1982-1983
oil on canvas, 48 x 72
Lent by the artist

Mark Wethli
Born in Westfield, New York in 1949
Educated at the University of Miami in Coral Gables,
BFA in 1971 and MFA in 1973
Lives in Long Beach, California

Foreign Interior, 1981
acrylic and oil on paper, 8 x 10
Lent by the artist

* *Landing*, 1982
acrylic and oil on paper, 9 x 12
Lent anonymously

Paul Wonner
Born in Tucson, Arizona in 1920
Educated at the University of California at Berkeley,
BA in 1952 and MA in 1953
Lives in San Francisco, California
Represented by Hirschl & Adler Galleries, New York, New York

* (x) *Dutch Still Life with Primroses*, 1977-1978
acrylic on canvas, 70 x 50
Lent by Security Pacific National Bank,
San Francisco, California

(x) *Dutch Still Life with Half Grapefruit and Blue and White Napkin*, 1979
acrylic on canvas, 48 x 48
Lent by Security Pacific National Bank, Los Angeles, California

Basket of Plums, 1982
lithograph, 30 x 22½
Lent anonymously

Selected Bibliography of Realist Exhibitions

This bibliography is limited to group exhibitions of realism from the mid-1960s to the present in California and the Pacific Northwest, exhibitions of West Coast realists outside of this area, and major national exhibitions of realism which included artists in WEST COAST REALISM. Exhibitions of individual artists are not included. After each listing, any artists from WEST COAST REALISM who were included in the exhibition are listed. In cases where an entry is incomplete, full information was unavailable.

San Francisco, California. San Francisco Art Institute. *East Bay Realists*. 1966. Traveling exhibition. Included Robert Bechtle and Richard McLean.

Los Angeles, California. Rental Gallery, Los Angeles County Museum of Art. *New Realism*. 1966. Included William Allan.

Los Angeles, California. Rental Gallery, Los Angeles County Museum of Art. *Aspects of Realism*. 1967. Curated by Henry Hopkins (then Director of Education at L.A.C.M.A.). Included Maxwell Hendler.

Balboa, California. Newport Harbor Art Museum. *Directly Seen*. March 11—April 22, 1970. Curated by Betty Turnbull. Catalogue with an introduction by Thomas H. Garver. Included Bechtle, Bond, Hendler, McLean and Raffael.

Stockton, California. Pioneer Museum and Haggin Galleries. *Beyond the Actual: Contemporary California Realist Painting*. November 6—December 6, 1970. Curated by Donald Brewer. Catalogue with an essay by Donald Brewer. Included Bond, Hendler, McLean and Thiebaud.

New York, New York. Whitney Museum
of American Art. 22 *Realists*. 1970.
Curated by James K. Monte. Catalogue with
an essay by James K. Monte. Included Bechtle,
Hendler and McLean.

Corona del Mar, California.
Jack Glenn Gallery. *The Cool Realists*.
1970. Included McLean.

La Jolla, California. La Jolla
Museum of Contemporary Art.
Continuing Surrealism. January 15—March 21, 1971.
Curated by Laurence Urrutia. Catalogue.
Included Allan and Wonner.

Oakland, California. Oakland Museum.
4 *Real*. February 22—April 2, 1972.
Curated by George Neubert.
Brochure with an introduction by
George Neubert. Included Mendenhall.

Santa Barbara, California. Santa Barbara
Museum of Art. *California Representation*:
Eight Painters in Documenta 5. 1972.
Included McLean.

San Jose, California. California State
University. *East Coast/West
Coast/New Realism*. April 24—May 18, 1973.
Catalogue. Included McLean.

Hollywood, California. Los Angeles
Municipal Art Gallery. *Separate Realities*.
September 19—October 21, 1973. Curated
by Laurence Dreiband. Catalogue with
an essay by Laurence Dreiband. Included
Allan, Bechtle, Bond, Hendler, Hendricks,
McLean, Raffael and Thiebaud.

Los Angeles, California.
Loyola/Marymount University.
The Realists Image. 1975.
Included Hendricks and Jenkins.

La Jolla, California. University of
California at San Diego. *Sense of Reference*:
Explorations in Contemporary Realism.
March 7—16, 1975. Curated by Moira Roth.
Brochure. Included Bond.

San Francisco, California.
John Berggruen Gallery. *New Realist Painting in California*. 1975. Included Boers, Bond, McLean, Mendenhall and Torlakson.

Portland, Oregon. Reed College. *American Realism*. 1975. Curated by Charles Rhyne. Included Boers, Bond, McLean, Mendenhall and Torlakson.

Seattle, Washington. Linda Farris Gallery. *New Realism*. 1976. Included Hayes.

Los Angeles, California. Cedar-Sinai Medical Center. *Directions in Southern California Realism*. 1977. Curated by Jim Murray. Included Bond and Jenkins.

Chico, California. California State University. *A Comparative Study of Nineteenth Century California Paintings and Contemporary California Realism*. 1977. Included Bond, McLean and Mendenhall.

Los Angeles, California. Arco Center for the Visual Arts. *Realist Painters, Los Angeles*. February 28—April 8, 1978. Included Bond.

Reno, Nevada. Nevada Fine Arts Gallery. *California Realist Painters*. 1978. Included Bond and Jenkins.

Denver, Colorado. Denver Art Museum. *Reality of Illusion*. July 13— August 26, 1979. Curated by Donald Brewer. Catalogue with an essay by Donald Brewer. Traveling exhibition. Included Ligare.

Santa Barbara, California. Santa Barbara Museum of Art. *Photo-Realist Painting in California: A Survey*. April 12—May 11, 1980. Curated by William Spurlock. Catalogue with an essay by William Spurlock. Included Bechtle, Bond, Ligare, McLean and Raffael.

Tulsa, Oklahoma./ Philbrook Art Center. *Realism/Photorealism*. October 5—November 23, 1980. Curated by John Arthur. Catalogue with an essay by John Arthur. Included Bechtle, Raffael and Thiebaud.

Seattle, Washington. Henry Art Gallery, University of Washington. *Illusionism: Handmade*. December 5, 1980—January 4, 1981. Curated by Harvey West. Catalogue. Included Lundin.

San Antonio, Texas. San Antonio Museum Association. *Real, Really Real, and Super Real: Directions in Contemporary American Realism*. March 1—April 26, 1981. Curated by Sally Boothe. Catalogue with essays by Linda Nochlin, Philip Pearlstein and Alvin Martin. Traveling exhibition. Included Bechtle, McLean, Raffael and Thiebaud.

Philadelphia, Pennsylvania. Pennsylvania Academy for the Arts. *Contemporary American Realism Since 1960*. September 18—December 13, 1981. Curated by Frank Goodyear. Brochure. Book by the same title published by Frank Goodyear on the occasion of the exhibition. Traveling exhibition. Included Allan, Bechtle, McLean, Mendenhall, Raffael, Thiebaud, Torlakson and Wonner.

Laguna Beach, California. Laguna Beach Museum of Art. *The Real Thing: Southern California Realist Painting*. April 30—June 10, 1982. Curated by Lynn Gamwell. Catalogue with an essay by Lynn Gamwell. Included Bond, Hendricks, Jenkins, Treloar, and Wethli.

Catalogue Design: Graham Booth,
 Fullerton, California

Color Separations: Color Ad Corporation,
 Buena Park, California

Typesetting: Orange County Typesetting,
 Santa Ana, California

Printing: Orange County Litho. Press,
 Santa Ana, California